Over to You

Over to You

Letters Between a
Father and Son

**John Berger
and Yves Berger**

PANTHEON BOOKS
NEW YORK

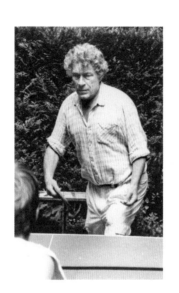

Long before my father had a studio built for me in the hay-loft of our house, we had a ping-pong table there. We loved playing together. I was a teenager, and he was in his sixties. We were pretty closely matched, and some days I won and others he did. But the result either way was a superficial consequence of what really made us play: the will to see how far we could challenge luck and make the exchange an act of grace. Of course that was very rare, but occasionally it happened, and then everything fit together—the rhythm, the movement and gestures, the timing, all converged in the unity of one single act.

Both of us made our drawings with the same joy and hope we felt when playing ping-pong.

I used to lose my temper when I played badly, and I would hit the table with my paddle. My father would rarely play forehand but was very fast with his backhand. When changing service and throwing the ball to each other across the table, we would say: "Over to you!"

<div style="text-align: right">Yves Berger</div>

I

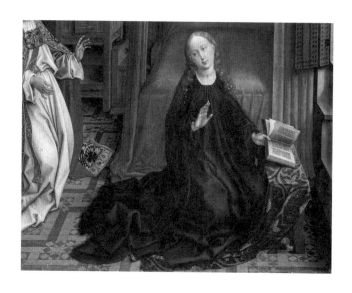

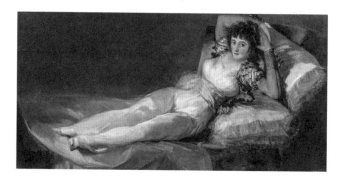

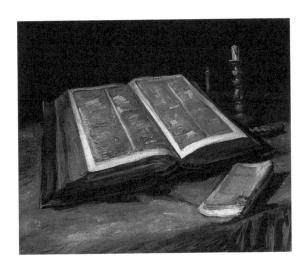

In the Rogier van der Weyden, Mary is reading about her future life in the Bible.

Van Gogh paints the Bible as a still life.

Goya paints his model posing but still dressed.

Both of the last two are an invitation.

Both lie open on drapery.

And how similar in their spatial perspectives are their open invitations.

<div align="right">Love, John</div>

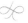

There is this saying: "I can read them like an open book." Isn't it a very nice way to express this desire we have to access what's inside? Inside what we are facing and its mystery. How we wish to penetrate the outside world surrounding us, not to take control of it but to feel more completely a part of it. To overcome the isolation we feel in our flesh. The terrible boundaries of the body . . . See how Chaïm Soutine was obsessed with reading the inside! *Le boeuf écorché* offers itself like an open book too . . .

LOVE, YVES

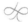

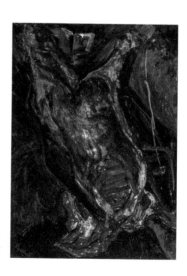

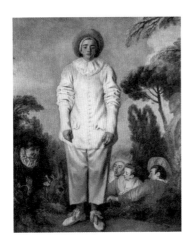 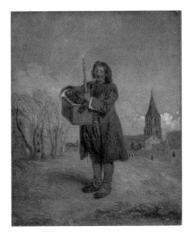

"To overcome the isolation we feel in our flesh. The terrible boundaries of the body..." Your words and the Soutine unexpectedly made me think of Watteau and his players and clowns. All the dressing-up and frivolities to hide the terrible border. I was looking for *Gilles*, and I came across the *Marmot*. One of our Alpine marmots that stand on two legs to see across the snow, now a gag in a box to make people in the cities laugh. Then I found *Gilles* and the donkey below and behind him. (Donkey and marmot might have a lot to talk about.) Inside his costume, Gilles's body has no border because joke after joke has dissolved the body into a sky. His body is becoming a cloud. He is painted like a landscape.

LOVE, JOHN

Gilles says: "I'm a stranger in a stranger world. I'm here but belong nowhere. I drift in this life of exile." The Savoyard with his marmot, from Saint Petersburg, replies: "Cheer up, don't fuss! See the sky today? No drama can happen under this blue. Nothing to worry about; the light won't fade, even when we die."

Over a century later, in New York, Max Beckmann paints a woman wearing a carnival mask. A cigarette in one hand, a clown hat in the other. She says nothing, but her black mask doesn't hide what her eyes tell: "Darling, you are as bad as me. Who do you think we are?"

Beckmann was a man of faith. "The great emptiness and enigma of space," he named God. All his life, he was trying to enlarge and deepen his knowledge of the world we live in. Light, as it were, was the vehicle for his quest. Drawing, the road. Hence his use of black.

Colors in his paintings come after form. They bring complexity and unexpectedness.

Look at a black-and-white reproduction: nothing essential is missing. Probably the same is true of Georges Rouault (who was born thirteen years before Beckmann and died seven years after). He too painted actors, clowns and mythological

scenes. He too had a strong faith. To the point that he could paint a sun circled with black.

X, LOVE, YVES

A few days before I got your Beckmann, I received a postcard from Arturo. Here it is. I put Dürer's *Screech Owl* beside Beckmann's *Columbine,* and together they made me smile. Their two faces and tummies wink at each other.

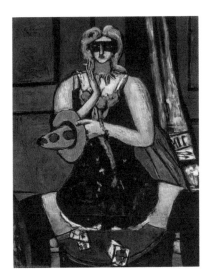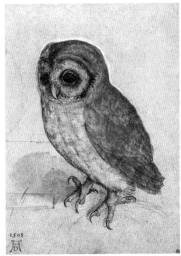

Also, both paintings present a species.

He is all screech owls throughout time; she is all women wearing a carnival mask! And of course this is linked with what you say about outlines, drawing and the use of black. And this made me think of images that insinuate the opposite. Kokoschka was an exact contemporary of Beckmann's. In Kokoschka, nothing is permanent and all is transient.

Even in his self-portrait with his beloved Olda, which is intended as a testimony to their lasting love, every brushstroke is fugitive, fleeting, momentary. And these qualities are proof that they are alive.

Kokoschka is very different from the Impressionists, for whom shifting sunlight was a miracle and a promise. For Kokoschka, light is a parting touch. When he was painting an aerial view of the Thames in London, I accompanied him for a moment to the roof from which he was painting it. This was in 1959. And his gaze was like that of a migrant bird about to leave.

LOVE, JOHN

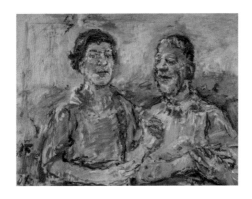

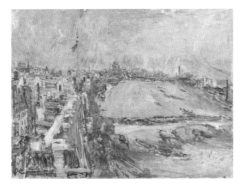

The gaze "of a migrant bird about to leave." Yes, a gaze that embraces space in such a way that the distant and the near are brought together. And this gaze creates a kind of map on which miles or kilometers pass by like the hours of a day.

Facing this, Kokoschka feels how fugitive light (and life) is!

Zhu Da, who belongs to an ancient Chinese tradition, feels the same but believes that light and life are eternal and that he is the fugitive! It's a question of perception.

Remember when, as a kid, I stood with you in a phone booth on a bridge in Geneva? And watching the water flow beneath our feet, I got scared and cried, convinced that we were drifting away.

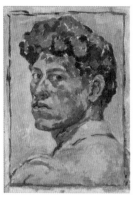

Zhu Da also drew and painted several species of plants, birds and fishes. (Maybe he even drew a mouse, which Dürer's owl would surely have gobbled up a century and a half later!)

But to Zhu Da, unlike Dürer, the idea of a self-portrait would never have occurred in the same way because the "self" already belonged to the species and the landscape and could not be separated from the rest of the creation. We couldn't be further away from the mindset of modern and postmodern Western culture.

Hence Giacometti's and Schjerfbeck's self-portraits. Following Ko-

koschka, they feel it's "departure time." Toward his future life for Alberto, to her approaching death for Helene. And

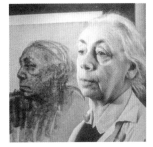

both look back . . .

For your pleasure, I add a photo of our beloved Käthe Kollwitz next to one of her self-portraits.

WITH LOVE, X, YVES

One of the first old master paintings to enthrall me and seize my imagination was Poussin's *Et in Arcadia Ego.* The three shepherds come upon a tombstone and thus discover that even in carefree sublime Arcadia, death occurs.

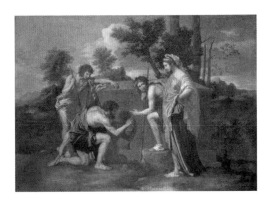

Poussin was obsessed with the question of what was and what was not eternal. Let's look at his *Landscape with Saint John on Patmos.* John is writing his vision of the Creation and God in a landscape that spans the whole of Time. And I want to compare this with a landscape by Zhu Da.

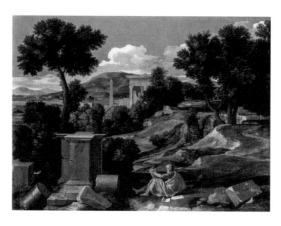

In the Poussin, the trees, the rocks, the distant mountain are painted in such a way as to emphasize their density, solidity and permanence. And in the Zhu Da, by contrast, the trees and rocks and mountains are brushstrokes and gestures. His vision is calligraphic.

At the same time, both landscapes are full of a sense of space, distance, nearness and permanence. Both question the notion of eternity. But what creation means to each of them is very different. For Zhu Da, God has written the world and he transcribes it; for Poussin, God has molded the world and he measures it.

For Zhu Da, there are no horizons but only pages and the spaces between words that are wisdom. For Poussin, there is an encompassing emptiness that has to be filled with prayers and angels.

In their later work, Giacometti will become, within the European tradition, a kind of calligrapher. And Helene Schjerfbeck a kind of keener.

LOVE, JOHN

Shi Tao lived at the same time as Zhu Da. In his famous *Sayings on Painting from Monk Bitter Gourd*, he wrote:

"You must first learn to know the *nearby* to be able to reach the *far-out*." And: "The landscape expresses the shape and momentum of the universe." Shi Tao believed that all creation could be represented, held together within what he named "the unique brushstroke." As if everything, including his art and himself, were eternally written.

Much closer to us in time, other artists have been writing the world. In the U.S., de Kooning and even more evidently Cy Twombly (note that the title of the reproduction I am sending you is *Arcadia* . . .). Even closer in spirit to Zhu Da or Shi Tao is Joan Mitchell, for she too shows her love and attraction to Nature.

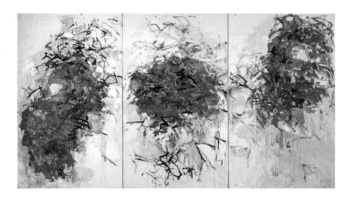

Nicolas Poussin. He always left me cold. It's only now that I can start approaching his work and feel its gift. (What prompts us, at a given moment and not before, to recognize a body of work, is a mysterious and fascinating question, no?) Many artists I admire refer to Poussin and the way he measured the world within its existence in time.

Measuring is an obsession for many artists. Among them, the most emblematic might well be Leonardo da Vinci. His famous studies, where writing and drawings support each other in order to get closer and closer to "how things are as they are." A complete encyclopedia of measurements—including animals, plants, human body, faces, clouds, machines, buildings . . .

Much less well-known, the British painter William Cold-stream was also obsessed with measurement. Patrick George says about him: "On a daily basis he would guess ages and heights on the underground, the distance between lampposts and the weight of babies." That fascination can be seen in his slowly developed paintings. And what makes this *Seated Nude* more touching for me than the Leonardo studies is that the most precise measurement doesn't stop the ongoing doubt about what he is seeing and about his painting it. Here the measures seem to hold together an endless sum of doubts, hold them together within the unity of an image.

Following Coldstream, Euan Uglow constructed in his studio a specific setup for each painting, allowing him to precisely measure the parameters, including light. In that way, he could find the right distance between the world in front of him and his inner feelings. He too called to Poussin for help . . .

LOVE, YVES

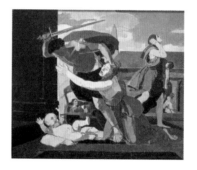

I had the good fortune to know Coldstream a little, and even to work beside him, drawing or painting from the same model. He wasn't at all bohemian; he had the air of an English gentleman who had just left his private library. When he painted, he entered a trance of concentration with its own total silence,

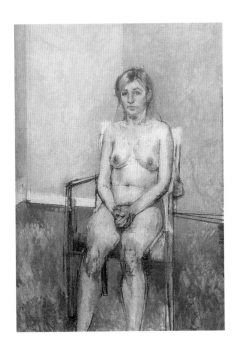

and whose stamina, as you so rightly say, was (is) doubt. Creative doubt. It was a great privilege to work beside him.

And what is so striking about the *Seated Nude* you sent is that she, the woman, the model, expresses this doubt, quite apart from the way she is painted, in her very being: in the way she is sitting, in her expression, in her hands, in the manner in which she occupies the space around her. She is the incarnation of doubt, waiting for her destiny, for what life will give her. Her body represents patience, endurance, hope, but not certitude.

So, by contrast, I send you this nude, *L'eau de Cologne,* by Bonnard. Here the woman, the model, has total confidence in herself, her body and the sunlight that bathes the world around her.

Just as the first painting shows us the doubt endemic to a certain profound manner of creation, the second shows us what a creation, when achieved, can offer to those who look at it, can offer to the world.

LOVE, JOHN

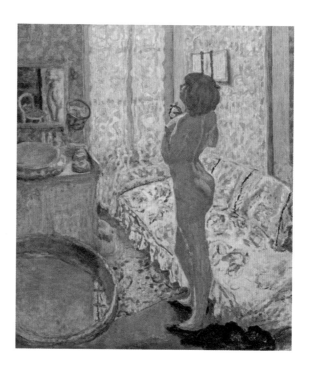

II

A proposal. Let's take a walk along a border. The border I'm thinking about is hard to name or even to locate. Maybe it's not even a border, but never mind, I'll try to take you there.

As I'm writing at a table in this "café," I'm listening to music. With my headphones on, I can concentrate better—the music helps me to cut off, to withdraw from this place and all its distractions. The music I'm listening to reminds me of Sufi music, like the singing of Nusrat Fateh Ali Khan. A kind of trance. A trip . . . Well, this trip would take us to the border we're aiming for.

Are the stars visible these days in the night sky of Paris? If so, look up at them tonight and start thinking—as we all know, but in a very abstract way—that they are mostly suns in other solar systems. But also keep in mind where you are, on this particular planet in this particular solar system. Now wonder about the scale of your life within the scale of life in general. Need a chair? Always better to lie down when looking at stars. Now you may be getting near the place I would like us to approach?

Let's take another vehicle. Both of us have had the experience of drawing in a life class, that's to say with a model, someone posing, nude. At first look, before we start really looking, it all seems pretty obvious. We all know what's a human body, male or female. Or do we? The more we look at it and try to draw it, to "represent" it on the paper, the more we doubt we know what we're looking at. To the point that we forget, must forget, what we thought of as our "knowledge," in order to face this fascinating mystery. And from there try to learn again.

It's true the human body is a very complex thing, and so this could explain why it remains, or rather becomes, so mysterious when we focus on it. But what about an apple? Or the way a coat hangs on a chair?

For each of those two, Cézanne and Giacometti have spent an endless amount of time and energy trying to grasp what it means, to see clearly.

And if you were to ask them, they would both say they had failed!

I came out of my mother's body. She came out of her mother's body. And so on . . . We can look at it from all sides, but there's always something *too big* for us in life. Too big to be able to think it, to see it, to hear it. And so to be able to carry on from birth to death, we each have to find a way to deal with this "too big." And the least we can say is that it's not easy. Maybe especially today in this world that leaves so little space for recognizing this weakness of ours.

So much exceeds our understanding. So much remains open in what seems, or even is, closed. This gap between our consciousness and our feelings, between the visible and the invisible, between the said and the unsaid, leads to a kind of vertigo. A vertigo that's not far from praying, or from madness. That's the zone where I would like us to meet. Are you coming?

<div align="right">WITH LOVE, YVES</div>

So here I am with you in the zone that faces the "too big." And I've brought with me two images because they have been on my table for months and I was glancing at them most days, and because they refer in their own way to what you are saying.

The first is a photo of a plant by Jitka Hanzlová—the Czech photographer of forests and horses! This image of a plant, when seeding, is as mysterious and as vast and as humbling as the sight of the stars in a night sky, don't you think? So physical scale has little to do with the intimidating "bigness." What is intimidating is perhaps the endurance involved?

The second is a painting we both know so well by Caravaggio. I send it because it depicts exactly that moment of vertigo or prayer that you refer to. Saint Paul, if you like, has just looked at the stars!

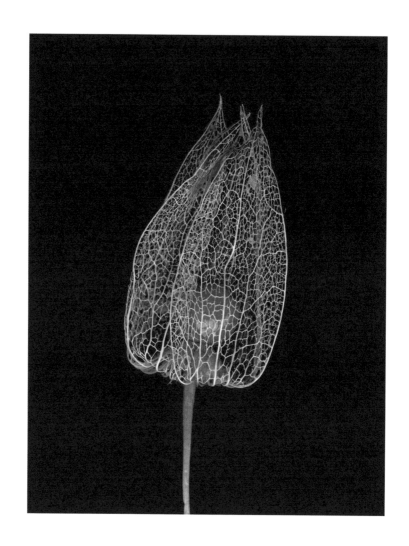

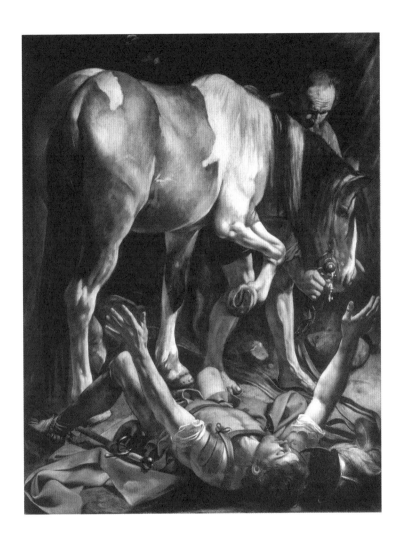

Yet what is so striking is the way in which Caravaggio has painted what surrounds Paul—a horse, a man, a cloak. These banal, everyday "presences" are painted with such wonder and intensity that they seem not ordinary but extraordinary. The horse's lifted foreleg and the man's standing leg are oceanic in their depth and their force. They are painted like a tempest might be painted.

But after saying all this, here we still are in the zone that faces the "too big."

When we face the "too big," are we not really facing the "too brief," that's to say ourselves, our minds, which have invented the measures—like "light-years"—for measuring the bigness? You say this too. But what I'm hinting at is that the bignesses are *our* invention, are part of our Being.

Then, if we follow Spinoza, and suppose that everything that exists is indivisible because this everything constitutes a whole, we see the bigness as something surrounding us, including us, rather than confronting us. And this is the mystery that art strives to present to us.

The figures that you are painting are messengers of this by their very presence. And their gestures show us or remind us of something we half know.

We acknowledge and recognize the immense whole with our actions (gestures) of solidarity and sharing. Such actions

embody *hope*—which is as big (not by what it promises but by its very nature) as the Big Bang, 13.8 billion years ago!

You still on the border?

<div align="right">W<small>ITH ALL MY LOVE</small>, J</div>

Me still on the border, but now where I stand there is a bridge. So I lean over and take a look down below. My God, what a gap!

It's true I can believe that everything is part of an immense whole—gap, bridge and me included. Just as I can say: "All that happens *had* to happen."

And if I were as wise as the gap is deep, I would stick to that celestial point of view and its eternity. It's a goal worth working for, as it is not a given!

But my feelings often bring me down. And then the depth appears to be vertiginous, the parts all separated. The heart beating faster with excitement and fear.

It's not a question of truth or reality but rather a question of how we make an arrangement with ourselves in order to live. Or, more precisely, in order to stay alive.

Recently I saw the film *Le Grand Bleu*. I had seen it long ago, and something about it always stayed with me. Not that it's a great film, but in its way, it's about this zone we're talking about.

The two main characters are free divers who push the limits of their bodies by going down as deep as possible in the sea, using only their lungs for breathing. The longer they stay under water, the deeper they go, the more dangerous it becomes. They are reaching and playing with a limit. At some point one says: "The hardest thing when you're down there is to turn around: you need a good reason to come back."

And finally the attraction of this limitless and dark world, a hundred meters below the surface, is so strong they offer themselves to it.

I think I like to recall that film because I feel something quite similar when painting in the studio. And when you bring up Caravaggio's painting, you yourself talk about an oceanic depth!

The plant Jitka took a photo of, which you sent me, is called in French *un amour en cage*. Both the image and the name set us wondering, asking: How? How can it be? Names sometimes do this: they double the mystery of what they are naming with their own mystery. So if you look outside, you will see the witch hazel is in flower, next to the waking-up strawberry plants and the still-asleep walnut tree (*wal-*

nut literally meaning "foreign nut . . ."). And equally, you won't miss the noisy magpies ("pie" being the Old French word for those birds, and "mag" apparently a slang word to name qualities generally associated with women, like chattering!).

So now, after this dive in the sea and this walk in the garden, I leave you in the hands of a friend who's taking you to a party, a very special party, located . . . guess where?

Xxx, Love, Yves

Like you say: the question is of staying fully alive! Francisco took my arm and led me to *The Burial of the Sardine.* It's so pulsing with energy, that painting! We don't talk because he's stone-deaf, and was when he painted it. Frankly, I don't think the subject of the popular celebration of the sardine on the last day of Carnival before the first day of Lent is very important here. For Goya, it was another scene of human craziness. As I went on looking at it, I was overwhelmed by the din, by the noise, the incomprehensible noise the huge crowd is making. And I imagine that when you are stone-deaf, there may be situations whose utter incomprehensibility is like a deafening noise!

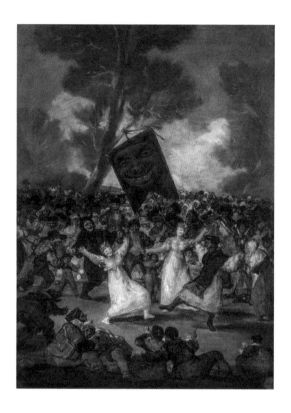

For those who are at *The Burial of the Sardine*, it's perhaps like a wild rock concert. For us spectators, it's a senseless, continuous roar. As Goya said: "The sleep of Reason produces monsters."

(My God! Look at what's happening in Israel and in Palestine; every pomegranate is bleeding . . .)

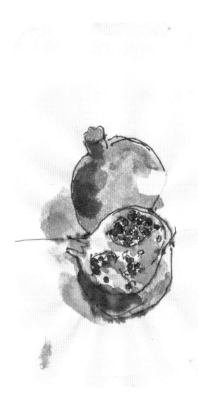

I too remember the film *Le Grand Bleu.* And if I'm not wrong, what partly tempts the two free divers to stay there in the depths and not come up to the surface is—the silence.

And so we have din and silence. Din obliterates explanations, and silence offers a continuous questioning present. Neither can help us much to be fully alive.

What can? Maybe asking questions. And questions are not only verbal. When you are painting, you are asking questions one after another.

The paradox about asking questions lies in the fact that the questioner believes that it may be possible to find an answer. And this is a kind of faith.

A kind of faith that is totally absent in most church pictures, but which is there, for example, in Morandi's jugs and bricks. No?

Yes, it's true that names sometimes double or amplify the "meaning" of what they're defining. Sunrise. Midday. Dusk. Nightfall. The Small Hours. Tomorrow . . .

WITH LOVE, JOHN

To "morrow," yes "terday"! (The definition of "terday" found on the internet: British slang for Today. It is used mostly in the South, around the East Anglia area. Pete—"I had sex with the sister [nun] terday." Dan—"I did that yesterday!")

I'm glad Francisco took you by the arm. It's true you've known each other for a long time. When you and Nella wrote *Goya's Last Portrait*, you spent many days and many nights side by side. I guess he hasn't changed since—as he

is dead—but you've become an older man. Did you tell him about your difficulties hearing and how your relationship with sound has changed?

I've always heard you address the Old Masters or writers or thinkers, those you admire and feel gratitude toward, as if they were comrades, standing right there, by our sides. Their physical absence—most of them are long dead—doesn't make the slightest difference. What has been lost is insignificant compared with their ongoing presence. A presence established not only by the works they left but also by the intensity of their impulse toward what they sought. The number of ramifications between different lives is incalculable, just as the shapes in which life exists are unpredictable.

So it could be a game between us—of going to a rock concert with Goya, or of knocking at a door in the Via Fondazza in Bologna and waiting for Signor Morandi to open it. A game. A form of make-believe but nevertheless, not gratuitous. For kids, games are more real than most of so-called reality.

Let's go back for a moment to *The Burial of the Sardine:* I agree Goya saw it as "another scene of human craziness," but it's different from many others he depicted. Battles, fusillades, misery, hunger, illness, the domination and narcissism of the powerful, the absurd rules that hold the world together—all this cruelty of the human condition affected Goya deeply, so deeply he was considered insane.

"Lucidity is dangerous, Francisco!"

"More than I can say . . ."

But here, at the burial, it's a carnival. People are playing, joking with and about human craziness. They take the mickey out of their world! For a moment, they join Goya, for they recognize and witness the same thing. But when they decide to laugh together, he turns around and starts crying.

"Some of your paintings, Francisco, are made out of tears."

"They didn't stop. I prayed in despair, but they didn't stop . . ."

To keep faith no matter what, to ask questions hoping we may understand, to learn to ask new questions in the silence or the din: Do we have another choice? Is there another way toward freedom beside this narrow path?

"I've lived here almost all my life.
Since Father died, anyway. My brother
Giuseppe never saw this place. Later,
Anna, Dina, Maria and I found a way
to arrange our lives in here. Protected
from the terrible sunlight (true din) and
preserved from the obscurity that swallows
everything in the unknown (the silence).
Have a seat! This is my refuge."

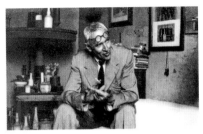

Aren't we lucky to be welcomed in this way by Signor Morandi? In his small world, one finds all the space one will ever need. And I wonder if what makes it so hospitable isn't precisely the faith with which Morandi painted his jugs and bricks. As if his hope can be found by listening to the conversation of things, as if we can remain in the company of things, remain in the company of a group of objects, even when they return to their solitude. In other words, as if a part of us keeps living in the place we have left.

Signor Morandi, you are the soul brother of Fra Angelico!

"I've always dreamt of spending a night in one of his cells, even though I dislike leaving my home . . ."

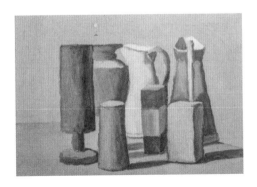

In our library in Quincy—my childhood bedroom—I hung four still lifes by Sven side by side. You see those small paintings on paper he did with oil sticks, quite late in his life? I love them more and more. Maybe because their fragility never fails . . . Never fails to what? Tell me about your friend Sven Blomberg. What was his example and his faith?

Oddly enough, I didn't tell Goya that, as an old man, I have become hard of hearing. Maybe I'm wrong, but I have the impression that he entitled one of his *Caprichos* "The Deaf Talking to the Deaf." In your old bedroom, there's a book of all his *Caprichos*. And I also have the impression that you looked at this book when you were still very young.

What you say about our artist predecessors seems to me right and important, i.e., that their "impulse" is even more encouraging than their works. And what their impulse signifies is their devotion to posing questions and to searching for partial replies.

Yes, the Carnival crowd is taking the mickey, and putting their arms around Francisco and sharing his laughter. And after a moment, tears come to his eyes. It's intriguing that both laughter and loss provoke tears.

I shut my pen and laid it on this sheet of paper. And when I
looked next, it had done this. Curious?

And my fingers are stained with Sheaffer black! (Somebody
pointed out to me the other day that *schaefer* in German means
"shepherd," i.e., Berger.)

In the photo you sent of Morandi, he's, as you say, listening as much as looking. Listening to the "conversation" between objects. Between two jars. Between satellites and the earth... between a pen and a clean sheet of paper.

Philosophers search for answers; artists seek and confront doubt. Scientists establish formulae; artists find metaphors.

You ask me about Sven. "What was his example and his faith?" you ask. In his way of life, he was unique, and I've never met another painter quite like him. Perhaps he had a little in common with Giacometti, whom he admired and whom he had known when he first came to France in the late 1940s. He did not paint to produce paintings. His studio was an upper room in the outhouse of a tiny farm, and was scarcely larger than a garden shed. He never invited anybody to climb up into it. His "finished" paintings he took off from their stretchers and stacked in a vegetable "loft" for onions. His chosen way of life served his mystical love of Nature—although in appearance he didn't look like a mystic but like an onion seller. His mystical love had something parental about it—as if Nature were the mother of everything and, at the same time, a child who needed protection. And both roles implied a constant conversation. When he was painting, he was tending the land in another way. He had no ambitions about exhibiting or selling his work. If a friend wanted to buy a painting (he had a good many friends from Paris who came to visit him in Lacoste, and they mostly belonged to philosophical milieux around Garaudy and Merleau-Ponty), he would put a high price on it but indicate that he was making a sacrifice because the

painting would no longer be there. Otherwise he, Romaine and their daughter, Karine, contrived to live without money. For transport, he had a bicycle. Later I got him a secondhand 2CV. For him, the act of painting was the act of kissing Nature. But, as happens in kissing, perhaps Nature was kissing him—her tongue thrusting toward his throat. He loved birds; they were like postmen.

The real postman refused to drive down the one-kilometer lane to his house (like yours to Vers le Mont), and he arranged a wooden box where the lane joined the tarred road. His one luxury was his library. He was very well-read, and the library was the largest room. Poetry and philosophy. Both he and Romaine would read while eating a meal, more often than not prepared by Sven.

Perhaps this tells you something about his example?

Over to you.

WITH ALL MY LOVE, J

I'm on my way home, on the train from Milano to Geneva. The landscape moving outside the window is gray and green. Gray because of the concrete and the roads, and gray because it's a gray day—as if the sky had abandoned its job

and wanted to do nothing (it's the first of May!). Green, fresh green, because it's the color of spring . . .

I love your description of Sven's way of life. And indeed it makes me feel the example he set and the faith he had. A faith that smelled of onions!

In Milano, as you know, I was invited to talk at Bocconi University (a private university well known for preparing students to be leaders of the economy in tomorrow's liberal and global world . . .). I was invited to talk to a group of student-researchers—as they call themselves—about my practice as a painter and my "way of life" as an artist today. The meeting took place and they were happy, but mostly I feel it was a failure. And I will try to tell you why. (The train is now passing along the lake before Domodossola with those little village-islands on it. You see? I know you took this train many times in your life . . .)

I had spent quite some time preparing for the talk. I had decided to use several sequences of photos showing my paintings "in progress." You know those photos because I took them at the end of each day, to send to you by email, for you to see what I had been working on, and for us to talk about it when we phoned each other in the evenings.

For each painting (finally I chose only three), I had a series of eight or nine photos, sometimes taken over a period of several years, of different stages along the long road that eventually led to the finished painting. As I was showing

them, I realized I hadn't really understood the risk of revealing such images in this way.

Our dear friend Maria Nadotti was the first to point out the problem: those pictures were misleading. First because they gave the impression of a linear process, as if Time were an arrow, whereas the real experience we have of it is made of folds, and folds within folds, sometimes touching one another.

Then, they were also misleading because of the nature of the photographic image as distinct from a painted image. When looking at a reproduction, we are aware we are not looking at the "real thing," the unique, original painted canvas, with its presence, or as your friend Walter B. said, its "aura." Here, with these photographs of a painted image that no longer exists—or is only "underneath" the final painting—we are in a quite different position. What we see pretends to reveal the unseeable, something like what happens in pornography, where one is offered what's behind, behind nakedness, behind intimacy. Of course it's a lie. A lie we, as the animal we are, partly believe in . . .

(For the second time, a patrol of border control police took a Black guy off the train, after going through his luggage with blue plastic gloves.)

What I'm trying to say above is that the kind of access those photos allowed into my painting process led the viewer to a sort of voyeurism, therefore asking themselves wrong or unnecessary questions.

I had hoped these photographs—so useful for me in our exchange—would have been a support for my talk. In fact, I had to fight against their simplifications when talking.

I think Sven, with his practice of kissing Nature, would have foreseen my mistake. He who didn't let anyone enter his studio . . . But I'm glad now to have learned something from it. (We should build monuments in honor of our mistakes, for its most of all from them that we learn, no? Let's propose it to the Ministry of Culture. What do you think, next to the monument for Le Soldat Inconnu?!!!)

The gray sky has come down even more, and now it weeps drops of rain. And those drops, on the windows of the train, move along, rolling almost horizontally, in the opposite direction to us. If I say it's due to the effect of gravity combined with speed and the nature of water and glass, does it diminish the poetry and the mystery of such an event? And I look at people looking out of the window, and say to myself: How beautiful . . .

Flowers. Drawing flowers. Painting flowers. Celebrating flowers. I think that could be the next chapter of our exchange. What better to do in the month of May?

WITH ALL LOVE, YVES

P.S. Under this sky, Lake Leman looks like the sea.

III

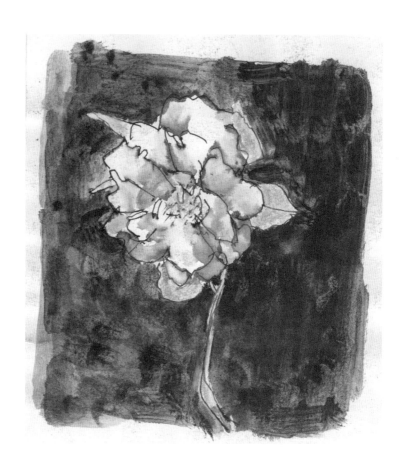

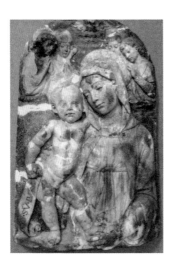

In answer to your last letter, I send two "postcards." One is a photo taken by Iona Heath of a terra-cotta by della Robbia, and the second a watercolor by me of a white rose from the garden.

The della Robbia family produced so many of those tender terracottas of Madonnas and angels offering gentleness and consolation to others in face of the cruelty of life, but this one suffered such cruelty itself, because it was burned in a fire in Berlin in 1945. When Iona sent me her photo, I found it very touching, and I put it where I could see it when sitting at my worktable.

Then Nella said, "Can you do a white rose?" And after a day or two, I made this sketch. After it was "finished," I noticed the next

day that it had a certain echo of the photo of the Madonna. Something a little similar in mood and rhythm. No? Neighbors on the same table. The rose doesn't offer consolation but resists by itself the cruelty of life.

And in this "collaboration" between the two images there is a colossal difference of timescales: the drama of the della Robbia painted terra-cotta spans over five centuries; the drama of the white rose takes place in five days.

And perhaps this phenomenon concerning the irrelevance of regular linear time to what our imaginations seize upon has something to do with presenting as an explanation the steps or stages of a work in progress, as you experienced it in Milano.

Perhaps when we are working, and particularly when we are drawing, we operate not in a present but in a future?

Your monotype of the two irises is a wedding invitation!

WITH ALL MY LOVE, JOHN

Yes, to some extent, time makes no difference. The light varies but still falls upon this sheet of paper on which I'm writing, as it did on the white rose you drew, and as it did on Andrea della Robbia's *Madonna and Child,* when it was still in his studio in Florence over five centuries ago.

Yes, your rose resists the cruelty of life; like some figures in Caravaggio's painting, it offers a space for light to set up and unroll its colors. And we, living with the same background of darkness, the same exposure to cruelty, we receive these in lighted subjects as a message of confirmation: "What stands does so forever."

Day after day, I'm looking at the reproductions in this book called *The Last Flowers of Manet.* The beauty of these images becomes more and more extreme as time passes, and I gaze at them fascinated . . .

Manet painted them between 1881 and 1883, when he was suffering the final stages of an illness that finally killed him at the age of fifty-one—some days after having a leg amputated. So these flowers were painted under those tragic circumstances.

Once you are aware of that, you can't forget it when looking at or thinking of these small "nature morte." Nevertheless, the flowers stand for themselves, and I don't think some-

one would guess "where" they come from just by receiving their gift. I think Manet forgot himself while painting these bouquets and their vase. He offered himself to the miracle of their existence (you can't be further away from self-pity!). "I would like to paint them all," he said at the sight of flowers . . .

There is something dramatic about them: they stand on the edge of the world. The glass vase has been placed at the extreme limit of visibility. Behind the flowers, there is nothing, not even a dark void. Just nothing. Following that, the bouquets present themselves as the last—or first?—thing vibrating in the light of our world. Maybe these paintings portray like no others the dialectic between life and death. Not Manet's only, but all. In that sense, they are gigantic!

Don't you think?

<div align="right">L<small>OVE YOU</small>, Y<small>VES</small></div>

You're right, Yves, those small, last paintings by Manet of flowers are gigantic. And they are so for the reasons you say. I have just one observation to add, and it's this.

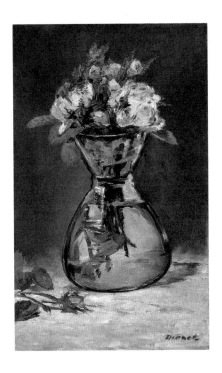

Each time he was given a sprig or a bunch of flowers (the word *bouquet* is too formal, implying something that has been elaborately composed and where there's no spontaneity), each time, he put it into a glass vase—or, once, into a champagne glass. And these glass vessels function like crucibles in the painting— that's to say, what is put into them is transformed, and Manet needed that transformation. He was as fascinated and spellbound by what he saw through the glass, within the glass, as by what he saw blossoming out of it.

Within the glass, the natural forms—their articulated space, their colors, their proportions—are decomposed. They become nonfigurative. We are looking through the glass at antecedent raw material. And Manet painted what he saw there as vividly as he painted the flowers, the leaves or the crystal of his favorite glass vases.

In each of the paintings, thanks to this, there is a section that beckons our eyes into a domain of the nameless, of forms that are still coming into being, or, perhaps, disappearing. They evoke a past or a future, both of which surround the present— the present that is entirely filled by the flowers.

As you so justly say, Manet placed the flowers he was about to paint on the edge of the world. Behind them, there is nothing. They are appearing at a first or a last moment, and they fill that moment as if it were the whole of life.

He paints their coming-into-being with such immediacy that we cannot but think also of their transience. "Maybe these paintings portray the dialectic between life and death."

They address whatever it is that precedes and follows existence. They address the raw material that surrounds existence.

What I want to add is that a reference to this raw material is there in these last paintings; it's there in what he saw and painted within the glass vessels, within the crucibles. It's there in each canvas.

And this reminds us of something, among many other things, that painting is about: the recuperation of the invisible.

Am I that far out?

No, Papa, you're not far out: on the contrary, you are asking central questions. "The recuperation of the invisible" is indeed like a huge backpack that "painting" carries on its shoulders.

Its weight can be a terrible burden, but strangely, it can also help the painter to move forward. To see beyond, or rather, within, the thickness of appearances. Isn't it a wish worth walking for? A lifetime commitment seems a small price to pay when one aims to undress time to its bare bones. Painting is that hope that can never be fulfilled, neither turned down.

A hopeless hope!

I've been reading a correspondence between the writer Valère Novarina and the painter Jean Dubuffet, and this is how Dubuffet puts it:

"The materiality of the objects we see is an illusion. And in that sense, a stone or a table doesn't differ in nature from a rainbow. Objects are part of the same flux. Therefore our

usual distinction between 'full' and 'empty' is no longer valid: everything leaps on, or over, a field of emptiness, of 'nothingness.'" (As we said about Manet's flowers standing in front of the "void.") So following Dubuffet, who argues that painting is a way of thinking, the painter has to convey, to invite and welcome beings to be part of the surrounding emptiness, to inhabit the ongoing nothingness.

By doing so, the painter allows thinking to be set free from its usual boundaries. And the mind can enter the incomprehensible. What you call—I think—the "raw material." And there, in that zone (again!), we find a language, a preverbal language. It's the domain of the nameless.

Surely Dubuffet and Manet come together in their fascination of what happens within the glass vessels, within the crucibles. Both praised—in very different ways—the terra incognita of the nameless, of the unformed, of the unthinkable. They praised it, not as the origin of all things but as the ultimate horizon, from which everything rises and to which everything returns. And for both, this recognition implied a strong sense of urgency (nothing rises and sets twice!), as well as a genuine modesty (nothing can be achieved, only attempted).

Now all this makes me think of your recent drawings of flowers and what you have said about drawing from nature.

A tree, a stone or a flower, when looked at through the act of drawing, can turn out to be a text you're trying to read. A text in an unknown language, a wordless language. From

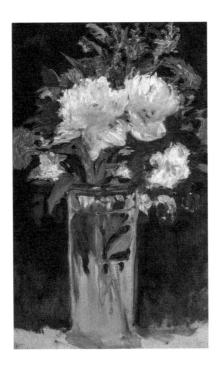

which you, with lines, shades and colors applied on the paper, try to make a sense of a form! The draftsman as the translator of the unnamed . . .

Not surprising then that so often we feel we are lacking the right words to say what we feel. What we feel in front of a flower, for example!

Not surprising either that most writing about art turns out to be a catastrophe. The misunderstanding may be there from

the start: we need to name things to recognize them, but by doing so we become separate from that thing we initially wanted to join.

So maybe yes, a drawing of a flower can be a form of relief, of resistance, in face of the ruling language of rationality.

Recently the French Socialist government agreed to let in a number of refugees but insisted that they be clearly distinguished from other migrants who only migrate for economic reasons.

Yesterday I told Sandra how much I liked the dahlias that bloom now, in the fall, as if it were their spring. Their freshness is joyful to witness in this landscape worn out by the long summer days. I told Sandra I doubted I would like them as much if they appeared in the spring. To which she rightly pointed out: "But such colors could never appear in springtime."

Soon the cemeteries will be covered with flowers. Let's both enter one: you near Paris and me in a village here. And let's try to look, listen and feel what kind of dance (that's Dubuffet's word) is going on there. Maybe then and there we'll merge more closely with the unnamed, the raw material ...

Hopefully!

WITH LOVE, YVES

IV

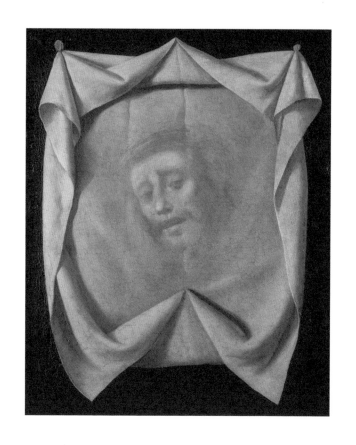

Let's begin with a painting by Zurbarán of Saint Veronica's veil. In fact, he painted two. One in which the head of Christ on the pinned-up veil is sharp and clear, and another in which his head is like a whisper of an imprint. The painting was in the museum in Valladolid in northwest Spain. The experts reckon that this one is the second, later version that Zurbarán made. You can hardly see the features of the face. Only the outline of Christ's hair, his ear and his beard.

And I start wondering and asking myself about the relationship between the touch—the sense of touch—and the art of painting.

In the Chauvet Cave, beside the painted animals there are the imprints of hands covered with the same paint.

Paintings speak to our eyes, but they also speak to our hands and stimulate our sense of touch. Don't they?

A great deal of what we see and are watching in life is untouchable. And the gift of the art of painting is to render such untouchable things touchable to the imagination of a spectator looking at a painting.

When we are drawing something that is in front of us, our drawing hand often instructs our eyes. And our eyes follow the order received.

JOHN

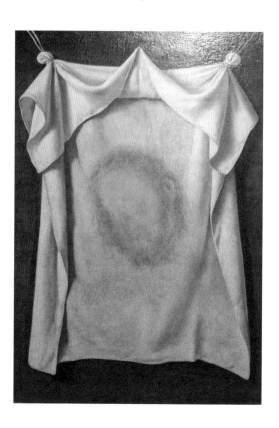

The woman who handed the veil she had over her head to Christ to wipe his face with was called Berenice, according to Nicodemus's apocryphal Gospel. The name Veronica came only after because of the nature of what the tissue revealed: the "true image," the "Veron-Icon."

You once gave me a wooden frame, without glass, in which you had pinned a black-and-white reproduction of the Zurbarán you're talking about. Against the wooden background, below the veil, you glued a little Arabic mirror with a blue metallic frame in the shape of an arch, and below that, a wooden Spanish fan, open. With those came a small booklet of a bird in motion: when you flip its pages, the bird's wings flap up and down. Remember?

Today as I was looking though the Zurbarán monograph we have in the hope of finding the Valladolid version of the veil, I found there was a missing page: the one you had torn out to give me!

The relationship between the sense of touch and the art of painting, you ask? I smile, and I feel chills.

Chills because for me it's such a central question. A question that underlies all the others I have as a painter. So deeply that I could say painting is touch made visible.

The brush, as any tool, is an extension of the arm and hand. Although it has no nerves running inside it, when we are

used to handling it, we feel what's happening between its hairs and the canvas with an extreme precision.

When it's a question of choosing which brush to use, it all depends on how you want to touch the canvas. With what kind of stroke?

Hands paint. Eyes correct. Hands can submit to eyes' decisions; nevertheless, hands are free. They are free because the art of painting depends on their freedom.

Shi Tao, whom we referred to before, says the origin of painting and calligraphy is celestial, whereas its achievement is human. Maybe "celestial" has to do with the sense of sight and "human" with the sense of touch?

I close my eyes and think of your back. I see it clearly, and no other back is like it (as vast and round as a planet). But it's my hands that make the image clear. My hands, which often massaged your back. If I think of someone's back I have only seen and not touched, I can't see it clearly: it's like any other.

You're right. So much of what we see is untouchable. Much more than one first thinks.

Pierre is in love with Marthe. He sees her with love as he touches her with love. Nobody else sees her that way as nobody else touches her that way.

For decades, Pierre painted Marthe over and over. So now, looking at his paintings of her, we are given a chance to see her through his touch: she is in reach of our imagination. And we feel for the fragility of her skin in the water of the bathtub. We are touched by it in return!

This afternoon in the studio, when I am not painting, my eyes will take me to the wooden frame to touch the veil again.

LOVE, YVES

The studio filled with the sense of touch. Fleeting hands dipped in different colors.

When I first went to art school (in 1943), the first thing I had to learn was the name of all the pigments and whether they were derived from plants or from minerals. Those that come from minerals intrigued me. Minerals had their origin in the creation of the universe. (The Big Bang theory had not yet been formulated.) Minerals were there before life began. Their colors were there before any eye had evolved. Cobalt blue. Cobalt comes from the mineral silver. During our first year at the school, we were forbidden to use ready-made tubes of paint. We had to go to a color merchant, buy the chosen powder and mix it ourselves with oils and turpentine and egg yolk. Fingering the

cobalt powder, I had the impression of fingering a prophecy that had waited milliards of years to be fulfilled. And now I could apply it with a brush.

<div align="right">

LOVE, JOHN

</div>

Here is the photo I have as the background on the desktop of my laptop. I took it a few winters ago, when grinding the color I use the most: white. I don't grind all my colors, but I do like to have my own pot of titanium white. I use a rather cheap ready-made white oil paint as a base, to which I add a lot of titanium pigments and just enough linseed oil to be able to grind the whole thing together. With my two hands on the glass muller, I turn it around and around in the shape of an eight—or the sign for infinity—until I reach the texture I want. A fresh honey–like texture, between solid and liquid.

As my hands repeat the gesture on the marble table, my eyes can gaze out the window. On the window-sill, I see the jars of linseed oil that have been waiting there for years (the more daylight it takes in, the

more siccative and better it becomes). Inside the jars, beneath the wrinkled skin that has formed on the surface, the oil is the color of gold. A liquid transparent gold, again like honey when it comes out of the honeycombs.

When I raise my eyes slightly from the jars and look beyond, I see the three beehives at the bottom of the garden. Whether it's a warm day or way below zero, in the center of those little houses, down in the heart of the swarms, the temperature always remains the same. The survival of the bees, like that of the human body, depends on that. After a while, grinding is like a dance; the movements of the hands and arms spread to the whole body. You get warm. Stop from time to time for a break. Or to gather in one place all the oily stuff that is spreading out all over the marble table. In front of the spatula you use to push the paint around, the mixture rolls like waves on the surface of the sea.

Usually there's snow outside when I make my pot of blanc de titane. Fingering the white oil paint while looking at the landscape wrapped up in its white blanket is joyful. Maybe because it simply makes me feel part of nature. I grind as it snows. But if we compare the two colors, my white is heavy and yellowish, more like piss than honey this time. Outside, the white of the snow is so pure you think: angel dust.

WITH LOVE, YVES

I see your photo of the homemade titanium white. Ever since I first learned the names of the pigments, titanium white has appealed to me. Zinc white was for mechanics, flake white was for decorators, but titanium white suggested Parnassus, where the gods hang out. So no wonder you make the figure eight with your palette knife!

For me, the equivalent of your photo is something I'd name "dictionary," yet it isn't a dictionary at all. It's the same as what you talk about later. It has the form of a beehive, and all the bees in it are syllables of words protecting the queen bee that lays the eggs of language. It's not a compendium of words like a normal dictionary; it's a maternity ward of words. This may seem strange, for a language is, after all, an established achievement, an historical edifice. But for a writer, the language he writes in (if he's a good writer) is always unfinished, tentative, expectant.

There are many references to honey in what you write. And I fancy that for us both, the house in Quincy and its identity were intimately associated, linked with beekeeping and the collecting of honey. The secret of the house was and is to be found in its honeycombs!

<div align="right">LOVE, J</div>

Honeycombs . . . Repeat that word and harvest gold. Gold made liquid; gold made light. Repeat that word and return pure into paradise, into the womb . . .

I often try to have gold in my paintings. Not real gold but a substitute pigment named Iriodin. Once applied, it shines depending on the light and angle from which you look at it. I often try, but it rarely works out. Indeed, it tends to remain artificial. And in that sense, gold is like ideas in painting: it works better when you accept giving them up!

Colors reveal themselves in the daylight, but what about in the darkness of an inside? Can we imagine the color of honeycombs inside the closed beehive? Or the color of the muscles, organs and blood inside a living body? Maybe all colors are multiple and their palette extends far beyond our visual capacities. Nevertheless, a painter must find a way through each and all of them.

After more than twenty years of painting, the difficulty I'm facing is different than before. It's no longer a question of arriving at a painting that holds together, that works as a composition or an image. I know, after some effort, how to get to that. No, the problem now is which image is worth keeping. Most of the time I must admit they don't deserve to remain visible. And so I work them over. Again and again, image upon image: a kind of endless process of re-covering. But always driven by the hope that *this* one will be the good one.

Eventually, often when despair takes over hope, when my will surrenders in face of the reality of what's there before me, when all ambitions are crushed and one is left like an idiot, when all the conditions meet—which is so rare—then

a painting worth keeping comes to life. Something magical that one can't really explain.

I may need time to see what's there, time for my eyes to be freed from all they have seen and looked for on that specific canvas. I may need other eyes to confirm what is really there. Like your eyes always did.

<div align="right">LOVE, Y</div>

V

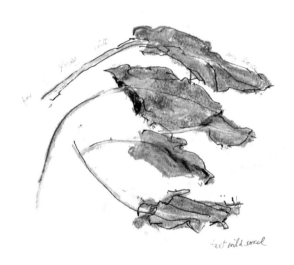

Drawing by John of wild sorrel leaves, given to Yves in 2016.
Together they decided it would be the starting point of this exchange.
2016, 20 x 25 cm, ink and pastel.

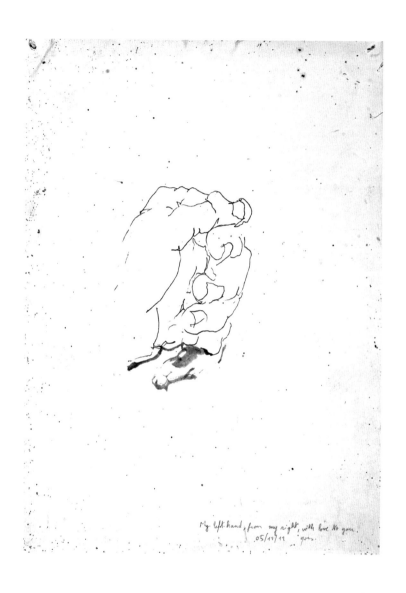

My left hand, from my right, with love to you.
.05/11/11 ...

Drawing by Yves of his left hand, given to John for his eighty-fifth birthday.
2011, 29.7 x 21 cm, ink.

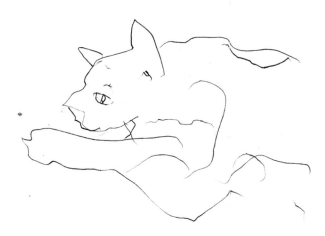

Drawn with my left hand whilst Nero hangs his head over my right.

Drawing of the cat Nero, done by John with his left hand
while the right one served as a pillow for the resting animal.
C. 2000, 21 x 29.7 cm, Sheaffer ink.

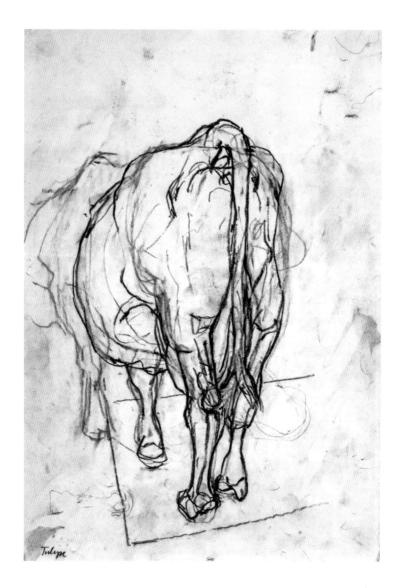

Drawing by John of Tulipe, the second cow on the right when
entering Louis's stable. C. 1998, 37.5 x 25.5 cm, charcoal.

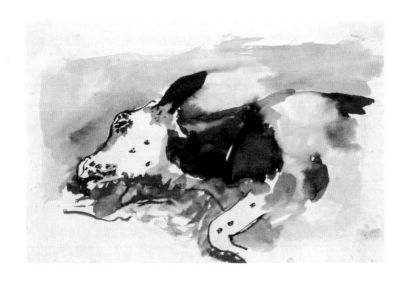

Drawing by Yves of a dead calf. Despite all efforts made, the precious
animal died a few weeks after he was born. Flies covered his eyes and body.
1998, 15.5 x 24 cm (in sketchbook), Chinese ink.

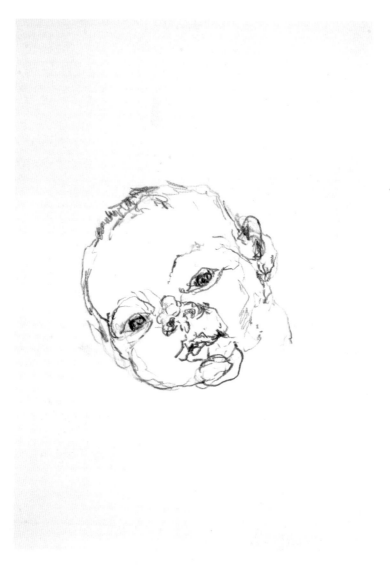

Drawing by Yves of his son, Vincent, not quite one year old,
done when visiting John in Antony. 2010, 40 x 25 cm, pencil.

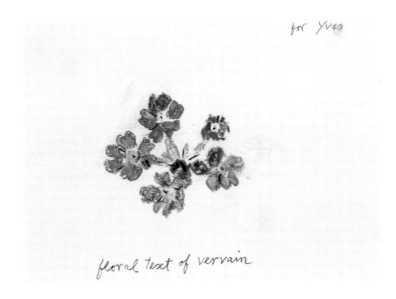

for Yves

floral text of vervain

Drawing by John of flowers of vervain.
C. 2010, 11 x 15.5 cm, pencil and pastel.

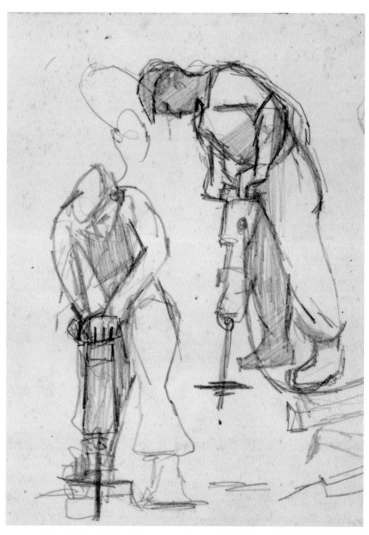

Drawing by John of construction workers. Part of numerous
sketches and studies and paintings done on building sites in
London as the city was being reconstructed after World War II.
C. 1950, 24 x 17 cm, pencil.

Drawing by Yves made after a trip the whole family took to the occupied
territories of Palestine and used in his book of poems *Destinez-moi la Palestine*.
2005, 29.7 x 21 cm, ink.

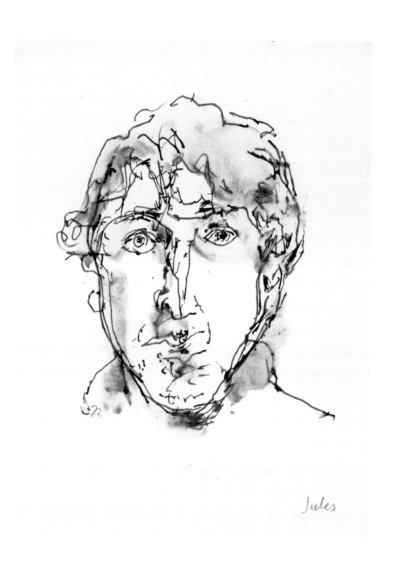

Jules

Drawing by John of Jules, a friend of the family.
2014, 29.7 x 21 cm, Sheaffer ink.

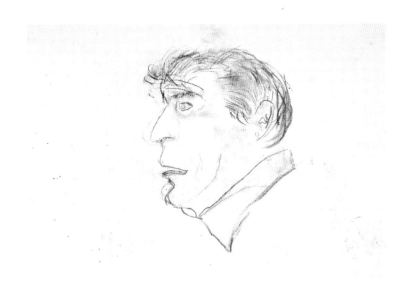

Drawing by Yves of John, who wrote in the bottom
right corner: *Yves. 10 ans. Portrait de son père.*
1986, 29.5 x 42 cm, charcoal.

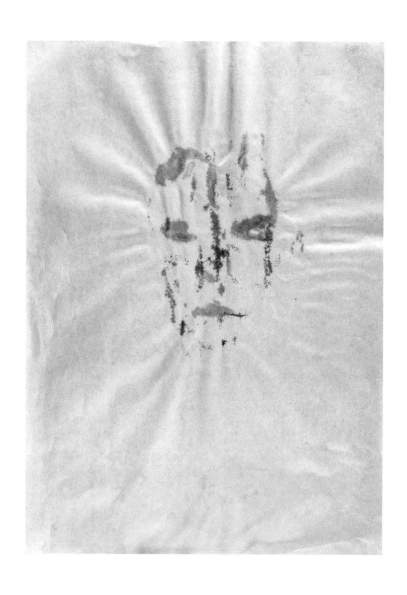

Reverse image of a drawing by Yves.
2010s, 32 x 24 cm, ink on Chinese paper.

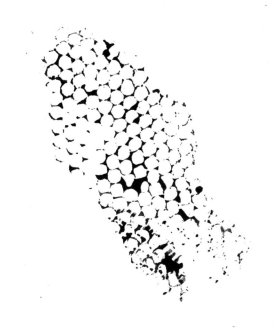

print from cells in a bee-hive ..

Print done by John, who wrote beneath it: *Print from cells in a beehive.*
Appears in *Bento's Sketchbook*. 2000s, 24 x 16 cm, ink.

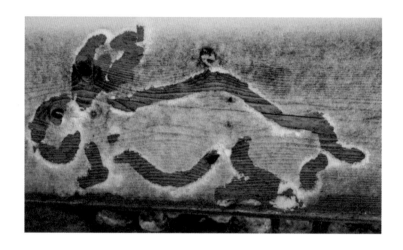

Photo of a drawing done by Yves in the fresh snow
covering the bench in front of the house. 1995.

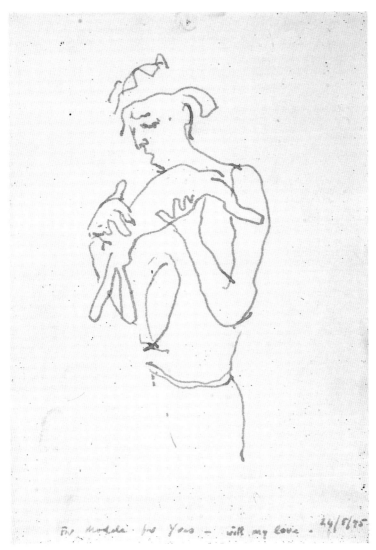

Drawing by John, faxed to Yves on the day his rabbit died.
The rabbit was called Model and had been Yves's motif during his
first year of work as a painter. 1995, 29.7 x 21 cm, ink.

Monoprint by Yves. 2015, 27 x 19.5 cm, ink on paper.

garde du vue . l'avenir : 10 minutes .

Drawing by John of a mouse trapped in a cage. When John would capture a
mouse in the kitchen of the house in Quincy, he would make a few sketches
of it, then take the car and free the frightened animal a few kilometers away.
2000s, 16.5 x 20.5 cm, ink.

Drawing by John of Slash, the lead guitarist of Guns N' Roses,
given to Yves, then age fifteen, a fan of the band.
1991, 65 x 50 cm, charcoal on paper.

Notes

Page 15: Arturo is Arturo Di Stefano, a painter based in London.

Page 31: Jitka Hanzlová is a Czech photographer who lives in Germany.

Page 49: Maria Nadotti is a journalist, translator, and essayist who translated John Berger's books into Italian. Walter Benjamin is an author and philosopher.

Page 53: Though this exchange began via postcards, as it continued, subsequent images were not postcards but other reproductions.

Page 68: Pierre and Marthe are the artist Pierre Bonnard and his wife and muse, Marthe de Méligny.

Page 80: Louis is Louis Sauge, a neighbor and farmer living alone with eighteen cows.

Illustration Credits

Page 6: Photograph of John and Yves Berger playing ping-pong. © The Estate of Jean Mohr.

Page 10: (*top*) Rogier van der Weyden, *The Annunciation*. Central panel of a triptych. Oil on oak, 86.3 x 92.3 cm. © RMN–Grand Palais/Art Resource, NY; (*bottom*) Francisco de Goya, *La maja vestida* (c. 1800–1807). Oil on canvas, 94.7 x 188 cm. © Photographic Archive Museo Nacional del Prado.

Page 11: Vincent van Gogh, *Still Life with Bible* (1885). Oil on canvas, 65.7 x 78.5 cm. Courtesy of the Van Gogh Museum, Amsterdam (Vincent van Gogh Foundation).

Page 12: Chaïm Soutine, *Le bœuf écorché* (c. 1924). Oil on canvas, 129.8 x 75 cm. © 2022 Artists Rights Society (ARS), New York.

Page 13: (*left*) Jean-Antoine Watteau, *Pierrot,* formerly called *Gilles* (c. 1718–1719). Oil on canvas, 184 x 149 cm. © RMN–Grand Palais/Art Resource, New York; (*right*) Jean-Antoine Watteau, *Savoyard with a Marmot* (1716). Oil on canvas, 40.5 x 32.5 cm. The State Hermitage Museum, Saint Petersburg. Photograph © The State Hermitage Museum. Photograph by Vladimir Terebenin.

Page 15: (*left*) Max Beckmann, *Columbine* (1950). Oil on canvas, 135.9 x 100.5 cm. © 2022 Artists Rights Society (ARS), New York; (*right*) Albrecht Dürer, *Käuzchen–Screech Owl* (1508). Watercolor. Erich Lessing/Art Resource, New York.

Page 17: (*top*) Oskar Kokoschka, *Self-Portrait with Olda* (1963). Oil on canvas, 89 x 115.5 cm. © 2022 Fondation Oskar Kokoschka/Artists Rights Society (ARS), New York/ProLitteris, Zürich; (*bottom*) Oskar Kokoschka, *Landscape of the River Thames* (1959). Oil on canvas, 91 x 123 cm. © 2022 Fondation Oskar Kokoschka/Artists Rights Society (ARS), New York/ProLitteris, Zürich.

Page 18: (*top*) Alberto Giacometti, *Self-Portrait* (1921). 34 x 25 cm. © 2023 Artists Rights Society (ARS), New York; (*bottom*) Helene Schjerfbeck, *Self-Portrait* (1944). Charcoal and wash tint. © 2022 Artists Rights Society (ARS), New York.

Page 19: (*top*) Käthe Kollwitz, *Self-Portrait* (in a photograph at the Ateliergemeinschaft Klosterstraße, with the artist). © 2022 Artists Rights Society (ARS), New York; (*bottom*) Nicolas Poussin, *The Shepherds of Arcadia* (*Et in Arcadia Ego*). Oil on canvas, 85 x 121 cm. Photo: Stéphane Maréchalle. © RMN–Grand Palais/Art Resource, New York.

Page 20: (*top*) Nicolas Poussin, *Landscape with Saint John on Patmos* (1640). Oil on canvas, 100.3 x 136.4 cm. A. A. Munger Collection, 1930. The Art Institute of Chicago/Art Resource, New York; (*bottom*) Zhu Da, *Above River*. Collection of the Honolulu Museum of Art. Gift of Robert Allerton, 1959 (2561.1g).

Page 22: (*top*) Cy Twombly, *Arcadia* (1958). Oil-based house paint, wax crayon, colored pencil, lead pencil on canvas, 182.9 x 200 cm. © Cy Twombly Foundation; (*bottom*) Joan Mitchell, *Chicago* (1966).

Oil on canvas, 261.62 x 485.14 cm. Private collection. Courtesy of the Joan Mitchell Foundation. © Estate of Joan Mitchell.

Page 24: (*top*) Euan Uglow, *Double Square Double Square* (c. 1980–1983). © Estate of Euan Uglow. All rights reserved, 2023. Bridgeman Images; (*bottom*) *Massacre of the Innocents, after Poussin* by Euan Uglow (c. 1979–1981). © Estate of Euan Uglow. All rights reserved, 2023. Bridgeman Images.

Page 25: Sir William Coldstream, *Seated Nude* (1952–1953). © Estate of Sir William Coldstream. All rights reserved, 2022. Bridgeman Images.

Page 26: Pierre Bonnard, *L'eau de Cologne* (c. 1908–1909). Oil on canvas, 124.5 x 109 cm. © 2022 Artists Rights Society (ARS), New York.

Page 32: Jitka Hanzlová, *VANITAS* 2008–2012, #5, untitled (2009). © Jitka Hanzlová.

Page 33: Caravaggio, *The Conversion on the Way to Damascus* (c. 1601). Oil on canvas, 230 x 175 cm. Courtesy of the Cerasi Chapel of the Church of Santa Maria del Popolo, Rome.

Page 38: Francisco de Goya, *El entierro de la sardina* (c. 1808–1812). Oil on panel, 82 x 60 cm. Courtesy of the Museo de la Real Academia de Bellas Artes de San Fernando, Madrid.

Page 39: John Berger, *Pomegranate* (2005). Watercolor on paper, 21 x 15 cm. © The Estate of John Berger.

Page 43: (*top*) Giorgio Morandi in his studio, at his family home in Bologna. © 1955 Leo Lionni. Used with permission of The Estate of Leo Lionni; (*bottom*) Giorgio Morandi, *Natura morta (Still Life)* (1952). Oil on canvas. © 2022 Artists Rights Society (ARS), New York/IAE, Rome.

Page 45: Letter from John Berger to Yves Berger. © The Estate of John Berger.

Page 52: John Berger, *White Rose*. Watercolor and ink, 21 x 21 cm. © The Estate of John Berger.

Page 53: Andrea della Robbia, *Madonna with Four Angels* (c. 1480–1490). Clay, colored glaze, 80 x 49 cm. Inventory number: 4997. Photo: Antje Voigt. Bildarchiv Preußischer Kulturbesitz Bildagentur/Bode Museum, Berlin/Iona Heath/Art Resource, New York.

Page 57: Édouard Manet, *Moss Roses in a Vase* (1882). Oil on canvas, 55.9 x 34.6 cm. Image courtesy Clark Art Institute, clarkart.edu.

Page 61: Édouard Manet, *Flowers in a Vase* (1882). Oil on canvas, 54 x 34.5 cm. Courtesy of Oskar Reinhart Collection, "Am Römerholz," Winterthur.

Page 64: Francisco de Zurbarán, *The Veil of Saint Veronica* (c. 1635–1640). Oil on canvas, 70 x 51.5 cm. Courtesy of Nationalmuseum, Stockholm.

Page 66: Francisco de Zurbarán, *The Veil of Veronica* (1658). Oil on canvas, 105 x 83.5 cm. Courtesy of Museo Nacional de Escultura, Madrid.

Pages 77–94: All images courtesy of the Estate of John Berger.

Page 102: Photograph of John and Yves Berger. © The Estate of Jean Mohr.

A Note About the Authors

John Berger is the author of many novels, plays, books of poetry, and works of nonfiction. An art critic and painter, he won the 1972 Booker Prize for his novel *G*. He died in 2017.

Yves Berger is an artist and the author of essays and books of poetry. In 2018, his exhibition *From the Orchard to the Garden* was shown in Madrid. He lives in a small village in the French Alps.

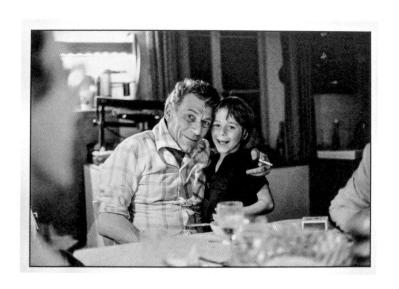

All rights reserved. Published in the United States by Pantheon Books,
a division of Penguin Random House LLC, New York, and distributed in
Canada by Penguin Random House Canada Limited, Toronto. First edition
in French published by l'Atelier Contemporain, January 2019.

Pantheon Books and colophon are registered trademarks of
Penguin Random House LLC.

Library of Congress Cataloging-in-Publication Data
Names: Berger, John, author. | Berger, Yves, [date] author.
Title: Over to you : letters between a father and son / John Berger and Yves Berger.
Description: New York : Pantheon Books, 2024.
Identifiers: LCCN 2023053509 (print) | LCCN 2023053510 (ebook) |
ISBN 9780553387575 (hardcover) | ISBN 9780553387582 (ebook)
Subjects: LCSH: Berger, John—Correspondence. | Berger, Yves, [date]—
Correspondence. | Art critics—Great Britain—Correspondence. |
Artists—France—Correspondence. | LCGFT: Personal correspondence.
Classification: LCC N7483.B474 A4 2024 (print) | LCC N7483.B474 (ebook) |
DDC 701/.180941—dc23
LC record available at https://lccn.loc.gov/2023053509
LC ebook record available at https://lccn.loc.gov/2023053510

pantheonbooks.com

Case illustrations by John Berger © The Estate of John Berger and Yves Berger
Case design by Linda Huang

Printed in China
First Edition

2 4 6 8 9 7 5 3 1